CO

INTRODUCTION

Rodents are the largest group of mammals in the world. There are almost 2,000 different species living everywhere on the planet except Antarctica. They range in size and nature from the sociable capybara of South America, which reaches an impressive 130cm, to the solitary pygmy jerboa of the Asian deserts, which is only 4cm long. The one thing they all have in common is their teeth. Rodents' front teeth, or incisors, keep growing their entire lives, and they must constantly gnaw on things to wear them down. In fact the term 'rodent' comes from the Latin word for gnaw, *rodere*.

People often associate rodents with pests – animals that destroy crops and spread diseases, but there is so much more to them than that. They play important roles in many eco-systems; providing a food-source for predators, dispersing the seeds that they eat, and often aerating the soil with their burrows. Like other animals, many rodents are threatened by global warming and the destruction of their natural habitats.

We think rodents are cool. We like the way they look and the weird things they do. This book is just the tip of the iceberg, but we hope you enjoy learning a little bit more about the wonderful world of rodents.

BROWN RAT

Brown rats, along with house mice, are considered to be the most widespread terrestrial mammal. In fact, outside of the Arctic, Antarctic and a certain province of Alberta, Canada, they can be found everywhere in the world, and are widely considered a pest. They can transmit various diseases to humans, contaminate food sources and cause damage to buildings by gnawing and burrowing. A single female rat can give birth to more than 40 young in a year.

Brown rats can be found in damp environments such as sewers, building sites and garbage dumps, as well as in residential areas. They live in hierarchical colonies in which large rats dominate smaller ones, and they rarely stray outside their small home territory. Their favourite foods are cereal products, but they will eat almost anything at all – including each other.

However, despite the negative press, rats can make great pets. They are easy to tame, intelligent, social and very curious. Due to the lessened exposure most people have to rats, allergies are relatively rare.

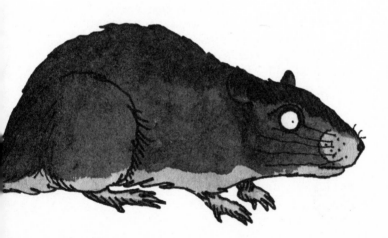

HAMSTER

Hamsters are chubby little rodents with stocky limbs, short tails, long silky fur and pudgy cheeks. They are native to western Asia, but are kept as pets around the world. The most common species of hamster is the Golden, or Syrian hamster, which can grow up to 18cm in length. They are clean, solitary creatures with poor eyesight but acute senses of hearing and smell. As nocturnal creatures, they will sleep most of the day and become more active in the evenings: playing, exploring and hiding.

The name 'hamster' is derived from the German word *hamstern*, which means 'to hoard', and indeed they are great hoarders. Their cheeks have dry, tough, expandable pouches, in which the hamster can collect and transport food and nesting material, to save up for the long cold winter. When emptying their cheek pouches, they will use their forepaws to push the food forward from the back of the pouch.

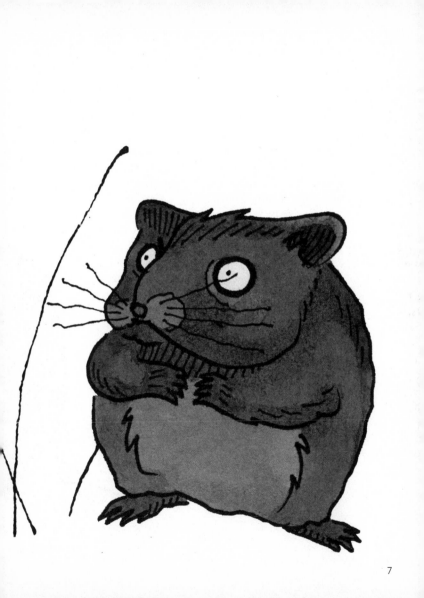

GREATER CANE RAT

Greater cane rats are common across much of sub-Saharan Africa, living in reedbeds and swampy areas along riverbanks. They are large stocky rodents weighing up to 7kg and measuring around 60cm long. They are closer relations to the porcupine than to rats, and are similar in looks. They have blunt muzzles, small fuzzy ears and strikingly orange front teeth. They have coarse, spiny fur on their backs, which deters predators. Greater cane rats eat grass and other plants, and are considered in some places to be a pest, causing damage to sugarcane, pineapple and cassava crops.

Greater cane rats are choice prey for pythons, leopards and birds of prey. Humans also hunt them for their meat, which is high in protein and very tasty – they often feature on menus in West African restaurants. Despite this, they are not a threatened species. They reproduce frequently and have good defences – they are strong swimmers and fast runners, and often outrun their predators.

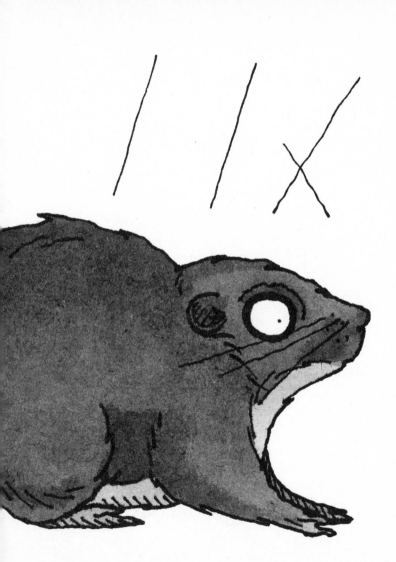

CHINCHILLA RAT

The chinchilla rat is a South American rodent with thick silky fur, similar to that of a chinchilla. Its body shape, however, is much more rat-like, with short limbs, large eyes and rounded ears. They are medium-sized rodents, measuring up to 25cm long, and are found in the South American Andes from southern Peru to central Argentina.

Chinchilla rats live at high altitudes in rocky, shrubby areas, and make their dens in rock crevices or burrows. They are good rock climbers, with tiny calluses on the soles of their feet that allow them to grip the surface. Some species build latrines that project from rock crevices and are made of hardened feces and urine. These structures can reach up to 3m high.

Chinchilla rats are hunted for their luxuriant fur, which is less valuable than that of real chinchillas, but desirable nonetheless.

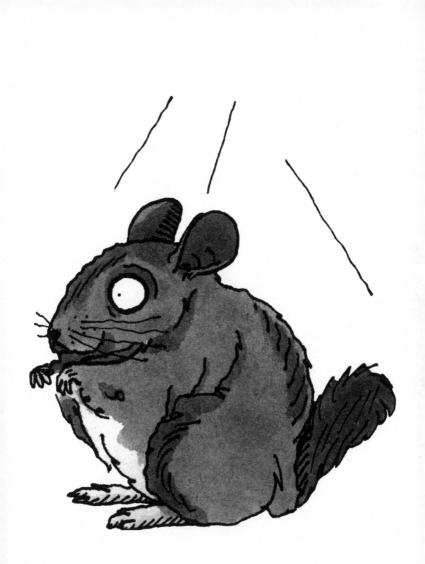

COMMON DORMOUSE

The name dormouse comes from the French word *dormir*, meaning 'to sleep', and these sluggish rodents indeed spend around three quarters of their lives asleep. The majority of their activity occurs at night between the months of May and October, and they hibernate for the rest of the year in nests under the leaf layer on the forest floor. With their big, shiny black eyes, rounded ears, fluffy tail and tiny bodies (only 5cm in length), common dormice are very endearing little creatures. They are a threatened species due to loss of woodland habitat.

GARDEN DORMOUSE

In spite of its name, the garden dormouse lives in forested areas, mostly in sunny parts of southern Europe. Much larger than the common dormouse, it measures up to 15cm long and has reddish fur with a black stripe along its face. Its tail has a white tuft at the tip. These rodents mostly eat animal protein; beetles, snails, nestlings, and even, occasionally, one another.

VANCOUVER ISLAND MARMOT

Marmots are large ground squirrels usually living in rocky, mountainous areas. The Vancouver Island marmot is one of the most endangered species in the world, with only around 75 animals left – and only 25 of those in the wild. It is a large rodent, measuring 70cm in length, with a thick, distinctive chocolate coloured coat, a paler muzzle and some white patches on its chin and chest. Like all marmots, it lives in burrows and hibernates through the winter.

Global warming, logging and the development of ski-resorts on their natural alpine habitat, have led to a population decline. There are a number of conservation programmes around Canada that are successfully breeding these marmots in captivity and reintroducing them to the wild.

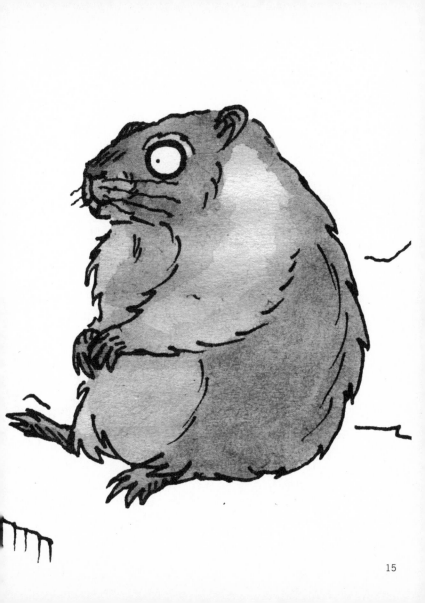

NAKED MOLE RAT

The naked mole rat is not going to win any prizes in the animal-kingdom beauty contest, but this African rodent is one of the weirdest and most interesting creatures you'll ever encounter. Measuring about 7cm in length, they are hairless, with tiny eyes that are almost blind and massive incisors that protrude out of the mouth with lips that close behind them. These teeth can be moved independently – spread apart or moved together like chopsticks, and are used to build vast, complex systems of tunnels.

The naked mole rat is very sociable. They live in colonies of about 100 individuals, out of which only one female and two or three males can breed. The rest are workers, digging miles and miles of tunnels and generating food by 'farming' tubers: they eat the inside of the plant root, leaving the shell intact, so that the plant can then regenerate itself, providing the mole rats with a future food source. Their skin is insensitive to pain, and they can live up to 29 years – an eternity in rodent terms!

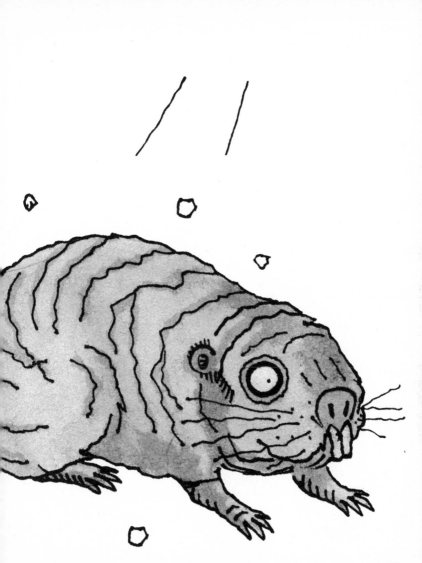

PRAIRIE DOG

These sociable, rabbit-sized rodents are a type of ground squirrel native to the grasslands of North America. They burrow elaborate tunnels with various rooms and chambers for nursing, sleeping and even toilets. The tunnels are lined with grass for insulation, and can be identified by the mounds of earth packed at their surface entrances. Prairie dogs live in large colonies or 'towns' made up of numerous prairie dog families. They are territorial but also very friendly, often greeting one another with a special prairie dog kiss and a nuzzle.

Prairie dog tunnels serve an important role in the prairie eco-system. They help keep the soil aerated, prevent erosion and also provide accommodation for other animals including snakes, burrowing owls and black-footed ferrets. However, the loss of open prairie and a new disease introduced by fleas has dramatically reduced the prairie dog population, and they are considered a vulnerable species.

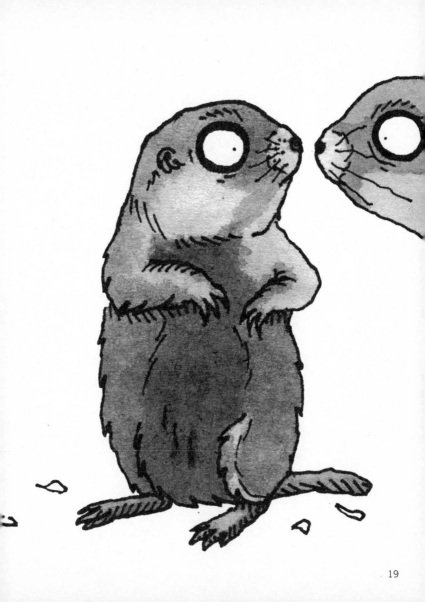

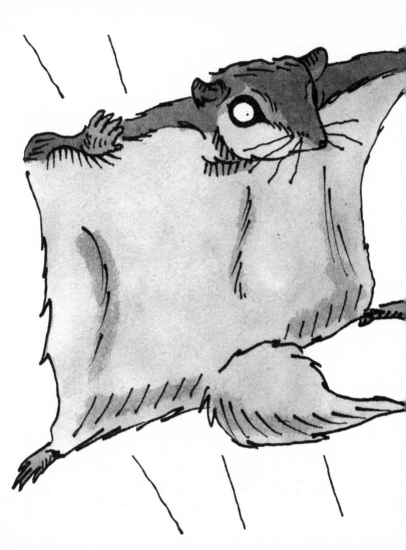

NORTHERN FLYING SQUIRREL

Found in parts of the United States and Canada, the northern flying squirrel's trademark feature is a unique parachute-like membrane called a 'patagium', which stretches between its forepaws and hindpaws, allowing it to glide up to 30m between trees. Its fluffy tail flattens out in the air, acting as a stabiliser, controlling its flight and allowing it to slow before reaching the next tree.

Flying squirrels are sociable rodents, nesting in tree hollows with other squirrels in order to conserve body warmth – which is essential, as they don't hibernate in winter. In one case 45 squirrels were found in a single nest, but usually the nest is shared between six or seven individuals.

They are nocturnal animals, hunting for food at night. They will eat lichens, nuts, tree sap, carrion and bird eggs, but flying squirrels have a particular taste for truffles, which they can sniff out from the undergrowth with their acute sense of smell.

NORTH AMERICAN BEAVER

Beavers are the animal world's most ingenious engineers. Using their strong front teeth, they cut down trees and plants in order to build complex dams and lodges. They serve an important role in the ecosystem – pruning back trees and stimulating new forest growth as well as slowing floodwaters and controlling erosion, although their dams can also occassionally cause flooding.

North American beavers are the third largest rodents in the world, reaching up to a metre in length. They are social animals, mating for life and living in colonies made up of big family units. Beavers are semi-aquatic. They coat their thick fur with an oily secretion called castoreum, and can close both their ears and their nose, allowing them to stay underwater for 15 minutes at a time. A thick layer of fat under their skin insulates them from the cold water. Beavers have webbed feet and a flat paddle-like tail that they use as a rudder to steer themselves and as an alarm signal, slapping the water loudly when in danger.

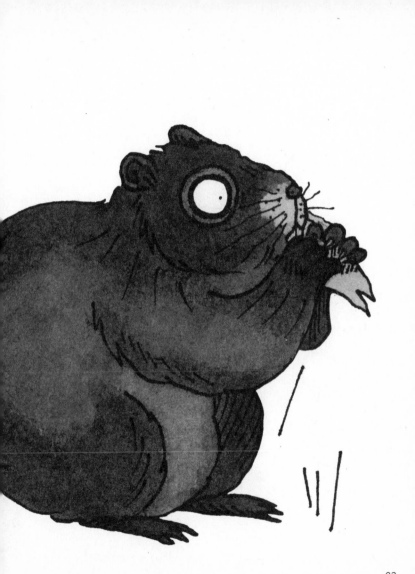

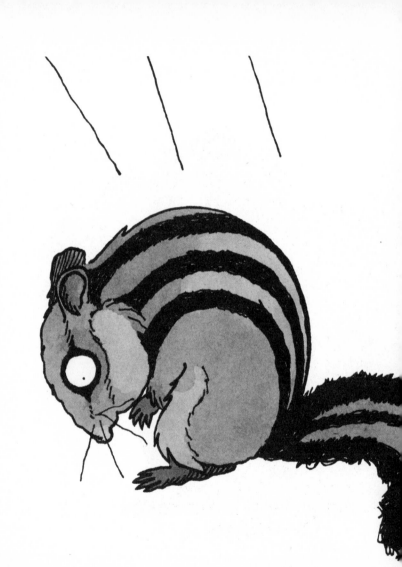

CHIPMUNK

These distinctive rodents have big eyes, bushy tails and reddish brown fur, with black stripes down their backs. There are 25 species of chipmunk, almost all of which are found in North America. They are solitary creatures that mostly live in long burrows, although some also live in logs and nests.

Chipmunks are omnivorous, which means they eat both plants and animals. Their diet mostly consists of grain, nuts, bird eggs and nestlings, small frogs, worms and insects. During the autumn months they spend most of their time searching for food, collecting it in their pudgy cheeks, which can expand up to three times their head size, and then stockpiling it for the winter months. Throughout the winter, they enter into a hibernation-like state called 'torpor', in which they stay in their burrows, using very little energy, and relying on the stores of food they built up in the warmer months.

SPRINGHARE

The springhare is a very unusual rodent mostly found in south-western Africa. Looking like a cross between a rabbit and a kangaroo, it has strong hind legs that allow it to jump up to 9m in a single bound. Its body measures up to 40cm long and is covered in soft yellowy fur, with black highlights on the head, back and tail. The springhare has very keen eyesight and hearing, and has a flap of skin at the base of its ear that can be closed to prevent sand from entering it.

The springhare is a nocturnal animal that lives in a system of burrows. When it emerges, it leaps dramatically out of the entrance to the burrow, in order to avoid any predators that might be skulking around.

It eats bulbs and roots, and can cause damage to crops, which means that it is often hunted by farmers. As a result of this and of the destruction of its natural habitat, the springhare is considered a vulnerable species.

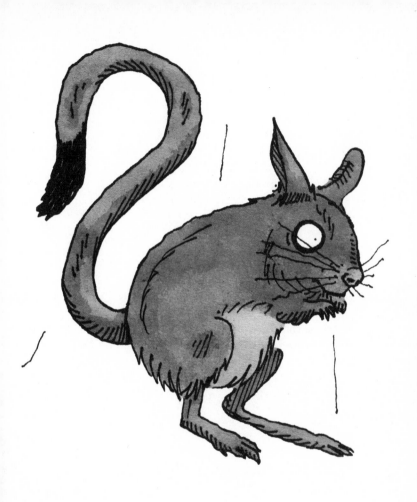

GERBIL

Gerbils are one of the most common rodents to be bred as pets. Although there are over 80 gerbil species, the most popular one is the Mongolian gerbil. In their natural habitat, the Mongolian steppe, these gerbils live with their extended family (clan) in a long network of chambers and tunnels.

Gerbils make great pets. First of all, they are friendly and social, and it's a good idea to get at least two, so they can keep each other company (but make sure they're of the same gender!). Secondly, they're diurnal (they're awake during the day), which means you won't have any squeaking wheels keeping you up. Finally, as desert creatures, they store water in their fat cells, which means they produce small amounts of urine and have dry faeces, so they're very clean.

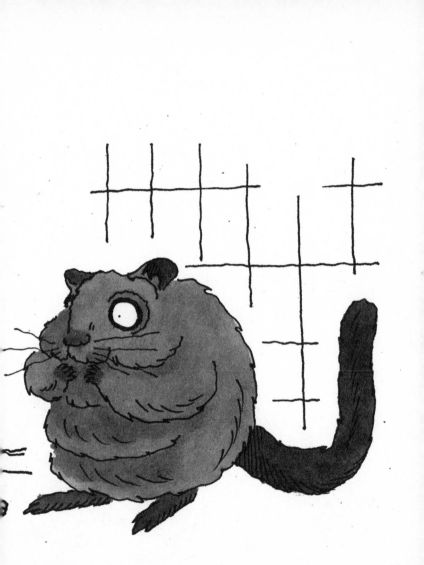

CAIRO SPINY MOUSE

Cairo spiny mice get their name from their coarse, quill-like hair that serves as a defense against predators, literally making them hard to swallow. They have a brittle tail that can snap off in part or in full if they are caught (once detatched it will not grow back), and big ears, which are thought to help cool down their bodies in their hot native climates.

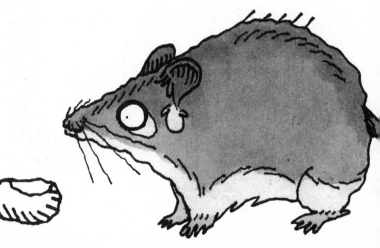

The Cairo spiny mouse is a very social creature, living in large groups. Females will often help with the nursing of each other's pups, but males tend to be more aggressive towards one another. They are very common across north-east Africa, and are often kept as pets in the Western world, due to their energetic, social nature and innate curiosity.

AGOUTI

The agouti is closely related to the guinea pig, and looks like a cross between a guinea pig and a huge tailless squirrel. They grow to around 60cm long and are mostly found in forested areas in Brazil, living in burrows or dense undergrowth. They are shy creatures, and very fast runners, so although they're not endangered, they're still quite hard to spot.

Agoutis play an important role in the local eco-system. They cover a lot of ground, and also sometimes bury their food for storage, which means they disperse the seeds of trees and bushes across a large area.

Unusually for rodents, agoutis live in monogamous pairs, which travel together. They communicate with each other using special calls. If they are alarmed, their coarse reddish fur bristles, and they make a series of grunts and squeals which warn other agoutis of danger.

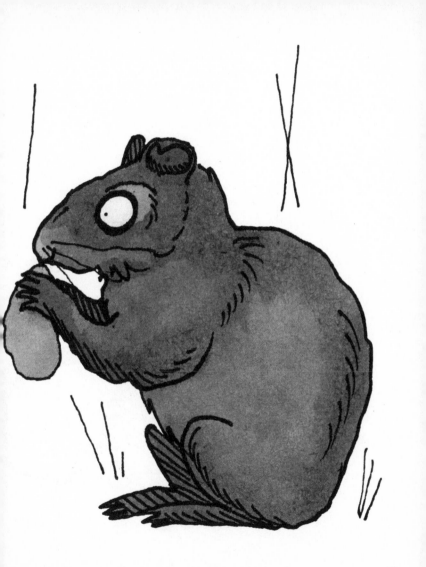

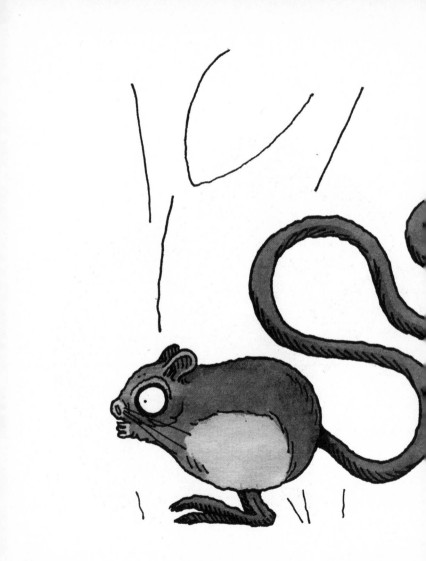

PYGMY JERBOA

Pygmy jerboas can be found throughout Asia and North Africa. Unlike most rodents that scuttle along on all fours, jerboas have the wonderful ability to jump from their hind legs, making them look like miniature kangaroos. They are the smallest rodents in the world, often measuring less than 5cm, and can leap several times their body length.

The pygmy jerboa has long silky fur, sandy on top with a white tummy. It has large eyes, a long tail and big feet with hair on the undersides, which allow them to grip the sand (a bit like snowshoes). They are shy and solitary nocturnal creatures, who live in well-camouflaged, complex burrows with different chambers for nesting, storing food and hibernating. They also build temporary burrows which are much more simple, used for hiding from predators whilst on their nightly hunts for food.

RED SQUIRREL

Red squirrels were once the only species of squirrel in Europe. However, in the late 19th Century, North American grey squirrels were introduced to Britain, bringing with them a squirrel-pox that had a devastating effect on red squirrels. In addition to this, grey squirrels aggressively compete for food, eating seven times the amount of red squirrels. As a result, the grey squirrel population in the UK has sky-rocketed to 2.5 million, whilst red squirrels are now protected with a population of only 140,000.

Red squirrels are smaller than their American cousins, with tufted ears and a coat that varies in colour from bright red to a reddish-grey. They shed their coat twice a year, growing a thicker, darker coat for the winter. Red squirrels are very shy, spending much of their time in the tree canopy. They come out in the mornings to look for seeds and berries, and rest in their branch-fork nests in the afternoons, when the predators are out.

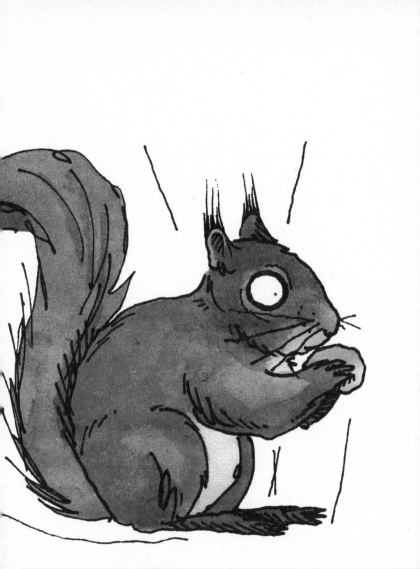

CAPYBARA

The capybara is the largest of all rodent species, weighing up to 200 pounds and growing to about 60cm tall and 130cm long. They live in grassy wetlands and near rivers across most of South America. Capybaras are semi-aquatic, and are excellent swimmers, with webbed feet and no tail. If they need to evade predators, they will stay underwater for five minutes at a time, or partially-submerged with only their nose and eyes visible (like a hippo) for much longer. They can even sleep this way.

The capybara is a social animal, roaming around in groups ranging between 10 and 100, and grazing on huge quantities of grasses. The group is usually dominated by a single male, who has a big shiny scent gland on his nose, which he uses to mark his territory. They are unusually communicative rodents and they will chat to each other through a series of barks, purrs, squeaks and grunts.

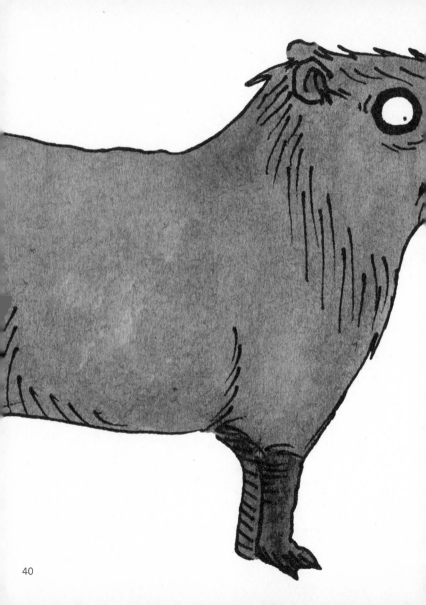

FOUR TOED JERBOA

This little rodent looks like it's had rabbit ears stuck on top of its rat-like body. They measure between 10 and 20cm, and their ears are the same length as their proportionately large head. Living in the salt marshes and clay deserts of Libya and the Arabian Peninsula, this jerboa digs shallow burrows for living, hibernating and hiding from predators. It lines its living nests with camel hair or its own belly hair for insulation.

This is the only jerboa species with four toes. On their hind feet they have a tuft of stiff hair, which acts as a steering mechanism for their long leaps, and also helps them kick sand out of the way when they are burrowing. Their fur is the same pale grey-brown as the sand they live in, and their eyes are large – a common trait in nocturnal rodents. Their long tail provides balance and allows them to slow their jumps before landing.

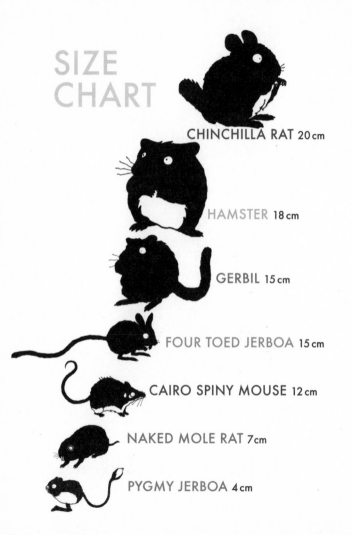

SIZE CHART

CHINCHILLA RAT 20 cm

HAMSTER 18 cm

GERBIL 15 cm

FOUR TOED JERBOA 15 cm

CAIRO SPINY MOUSE 12 cm

NAKED MOLE RAT 7 cm

PYGMY JERBOA 4 cm

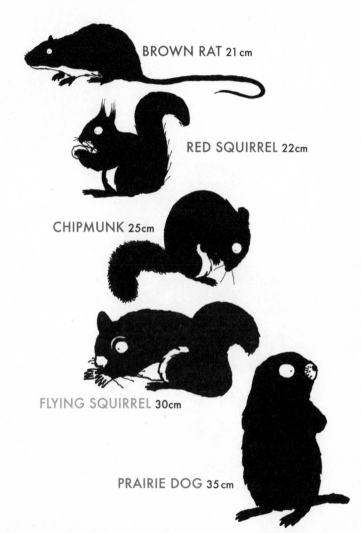

BROWN RAT 21 cm

RED SQUIRREL 22 cm

CHIPMUNK 25 cm

FLYING SQUIRREL 30 cm

PRAIRIE DOG 35 cm

45

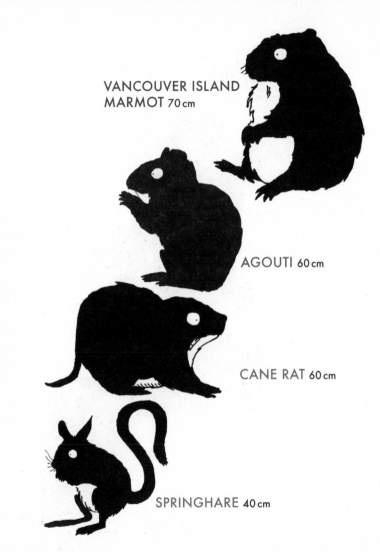

VANCOUVER ISLAND
MARMOT 70 cm

AGOUTI 60 cm

CANE RAT 60 cm

SPRINGHARE 40 cm

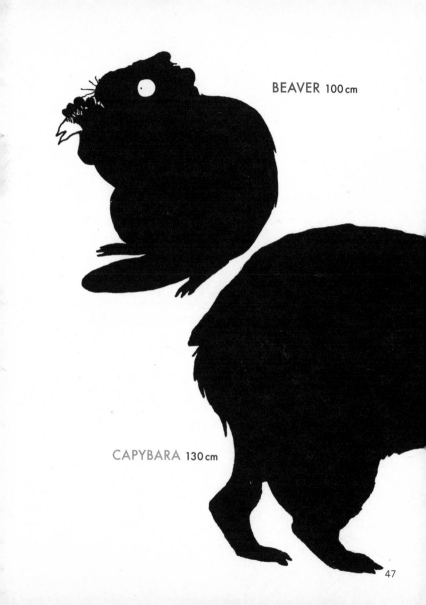

BEAVER 100 cm

CAPYBARA 130 cm

47

Published by Cicada Books Limited

Written and edited by Ziggy Hanaor
Illustration and design by Thibaud Herem

British Library Cataloguing-in-Publication Data

A CIP record for this book is available from the British
Library
ISBN: 978-0-9562053-1-5

Printed in China

Cicada Books Limited
76 Lissenden Mansions
Lissenden Gardens
London, NW5 1PR

T: +44 207 267 5208
E: ziggy@cicadabooks.co.uk
W: www.cicadabooks.co.uk